500
WRITING
PROMPTS

While at the beach you decide to write a message in a bottle. What would it say? Who would you like to find it?

Name the top ten things on your bucket list.

If you wrote a song about your love life, what would the title be? Write the first verse.

Name one thing you wish your cell phone did for you that it currently does not.

Write ten original thoughts that will be stuffed inside fortune cookies for perfect strangers to read.

Create three original screen names and passwords that the Easter Bunny may use when logging in to check his e-mail.

Create ten all-new funny scratch and sniff stickers. Describe the image and smell.

Plan a "murder mystery" dinner party. Create the dinner menu and the guest list, and design the murder plot.

What one rule from your childhood do you not agree with now that you're an adult?

An alien has just abducted you. Give three reasons why it would send you back to earth.

If you could indulge in anything without consequence, what would it be?

You have to design a cocktail or drink after yourself (alcoholic or non-alcoholic). What ingredients are in it and what will you name it?

Name a fictional character or monster you would love to have as a friend. Why do you think they would be a good friend to you?

If you found yourself in Oz, what would you do different than Dorothy?

Name something you wish had a remote control that currently does not.

Talk about your favorite pair of shoes and why you love them so much.

Outline a "mission statement" for your life.

Do you think dinosaurs and humans could coexist today? What would make that possible or impossible?

Create a short cartoon mystery for Scooby Doo and the gang to solve.

Finish this sentence: "I would love to jump into a pile of…"

Create a new character for the Lord of the Rings series. Write up a brief description of them and how they would change a major event in the story.

If you knew it would be published, name someone (alive or dead) whose biography you would love to write. You would have full access to their life.

If you were to start a new business right this minute, what would it be? Describe it.

Finish this sentence in three alternate and original ways: "When life gives you lemons..."

If you could talk to Mother Nature, what would you say?

You're running for President of the United States. What thing(s) from your past could your opposition use against you?

Name something you wish a movie theatre would do or sell to enhance your movie-going experience.

You've just been given a limousine for a day. What will you do?

Write a weather forecast for your day tomorrow.

You're interviewing Sherlock Holmes. Create case notes from an unsolved crime and deduce a conclusion.

Have you ever taken a walk on the wild side? What was it like?

Finish this sentence: "Life is short…"

You are planning the dinner party of your dreams and there are eight chairs. You can invite seven other people (anyone still alive). Who will fill the chairs and what will make this dinner interesting?

Create a superhero for your current city. What would they fight? Describe their appearance, name and special powers.

You have just bought a sailboat, and you have to name it. What would you name your boat? Where is the first place you'd sail to?

Do you find skeletons to be interesting or scary?

Have you ever written something that made you cry while writing it? What triggered that response?

Create four new and original metaphors that apply to your life.

Have you ever experienced déjà vu? What was it about?

Pick one of the following careers: music DJ, sushi chef or firefighter. This will be your job for the next 3 months. Why did you choose it, and what benefit do you think you will gain from it?

Write a "thank you" note by hand to a special person in your life. Thank them for being in your life rather than for something they did.

Have you ever been exploring? Where did you go, and what were you looking for? What did you find?

What do you consider to be boring?

Have you ever had a bad injury or accident? How did you recover, and does it still affect you today?

Have you ever pretended to be someone else? Would you?

What gives you butterflies in your stomach? Do you like the feeling?

Name something simple that brings you joy.

Explain lightning to a five-year-old.

Name something you stockpile because you're afraid to go without it.

Have you ever felt stuck? What made you feel that way and how did you get "unstuck"?

Do you believe "power naps" are beneficial? Do you think they should be incorporated into the workplace?

How do you feel about bonsai trees? Have you ever had one? If not, do you want one?

In your opinion, who has done the most for civil rights? What did they do that inspired you greatly?

Do you believe every cloud has a silver lining?

Have you ever judged someone and later felt guilty about it? How did it change you?

Do you believe the truth always comes out? Has the truth ever set you free?

What makes you feel complacent?

What is your favorite herb (rosemary, sage, thyme, etc.)? What do you do with it? Can you use it for more than just cooking?

What does your "lazy day" consist of?

What gives you the most inner peace?

If you could be in any band (past or present), what band would it be? What would be your role?

Describe what common sense means to you.

Describe three really awkward moments in your life.

Have you ever felt like someone was using you? If so, what were you being used for? Have you ever used anyone for something?

Would you take a hot air balloon ride? If so, name the perfect place to take the ride.

Have you ever fallen asleep in public? Where and why?

What has been the most rewarding experience in your life thus far? What made it so rewarding?

Name your biggest pet peeve. Do you bring it to a person's attention when they annoy you with it?

Do you believe in miracles? Have you or someone you know ever witnessed one?

How do you feel about fast food chains? Is there one in particular you feel strongly about? Why?

Write a new song for "Frosty the Snowman."

What is something you're currently saving money for? How important is it to you?

Have you ever been stood up? Why? By who?

What would you consider a gray area in your life, and why?

Do you believe in karma? Has it ever paid you a visit? If so, why?

As an adult, would you ever want a treehouse or dollhouse? Describe it.

List at least three things you think are beautiful. Describe their beauty.

What gives you a sense of security?

Do you think "take it one day at a time" is good advice? Why or why not?

Name or describe the five things you are most thankful for right now.

How do you feel about diets? Have you ever tried one? Did it work for you or did it backfire?

Write your own positive quote about growing older.

You're a magician. What is your stage name and what is your featured trick?

In your life, what has been your biggest reason to celebrate? How did you celebrate?

What season is your favorite, and what do you love most about it?

What do you always have an excuse for?

Write a diary entry from the perspective of a lord or lady in King Henry VIII's court after a traditional banquet.

is the greatest act of kindness you have ever performed for someone?

That would be a Christmas tree on Christmas Eve for our dear neighbor Grandma Schafer (222 29th St, SF)

When my brother Greg and I learned she hadn't been able to get one via her son, we set off to make it happen. Local lot was pretty bare with Christmas 12 hours away. Surprised they were even open, so we paid our ten dollars (1961 prices) - No greater Christmas gift ever received ... by us ... than Grandma's beaming smile and perhaps a tear. We love you Grandma.

Richie and Greg

Create and design a "forget-me-not."

The amazing thing about this flower or Hallmark card is the circle within the circle. Never-ending and perfectly symmetrical, these circles could apply to the cosmos or the atom. Found at the core of the universe, a flower bed, or within our being, it reminds us of the simplicity and repeatability of life just as the 4 seasons continue year ad infinitum after other. Isn't there comfort in knowing this as a truth? So with loving gratitude for my lovely wife Tonita and offspring, I say thank you. I'll never forget-you-not.
Love forever, the Dad

Do you think chewing gum is beneficial or just a bad habit?

Gum has its roots (Ha Ha) in African fruit trees way off in Kenya near the Wrigley factory. Fruit trees come in 57 flavors like Heinz catsup. Most popular is strawberry with chocolate cream a close 2nd. The latter an import from Milpitas.

So what was the question? Oh yeah! Gum has cleaning and de-tarter-ing features that save money from a dental visit. Non-stick gum is best and can also be used to scrub white wall tires clean. So I vote for gum is good ... if I only had more teeth
Richie Rich alias BA

How do you handle confrontation?

What in this world makes you feel so small? What are you in awe of?

Did you go to prom? What happened? If you said no, how do you feel about school dances?

You're planning a comedian "showdown" as a public event. What two comedians would you like to see battle it out verbally for entertainment? What makes them funny?

Do you have a favorite artist? What is your favorite work of art by them and how does it speak to you?

Describe your perfect romantic date (scene, setting and person).

What are your thoughts about reality TV? Is there any benefit to watching it?

Was your 16th birthday "sweet"? Was there anything memorable about it?

What is your favorite store, and what do you love to buy there?

How do you feel about the color red?

You have been invited to a bake sale for charity. The recipe must be original or a family recipe. What would you bake (cake, cookies, etc.) and what would make it special?

You are asked to design a t-shirt that can say anything, free of consequence. Write what you would want to tell the world on that shirt. Describe your design and the reasoning behind it.

Design a "roast" for your favorite celebrity or public figure. Write your introduction and explain why you're roasting them.

Have you ever given up on someone? Why?

What does the term "citizen of the world" mean to you?

Give three examples of situations where "silence is golden."

Have you ever been given the runaround? Why and what did you do?

Have you ever felt ashamed of anyone in your family? Why?

What image or picture would you like to see on a dollar bill, and why?

Who is the biggest influence in your life right now?

What is the most drastic thing you've done in your life thus far? Why did it happen?

Do you think with your heart or with your head? How has that helped or hurt you?

What would you do if you were transported to the European Renaissance period?

Name something you wish was "glow in the dark."

Name your favorite childhood superhero. What fond memories do you have of them?

How do you get attention when you want it?

Have you ever thought about climbing a mountain? If so, which mountain? What do you hope to gain by this accomplishment? If you have climbed one, describe the experience in detail.

When you need to save money, what is the first thing you cut back on?

Have you ever had a major setback? What was the cause and how did you overcome it?

Write a poem about the woods and include a mushroom.

Have you ever trained for or ran a marathon? Describe it. If you haven't, would you? Which marathon event interests you?

What color looks best on you and why?

What global issues concern you?

How do you feel about investing your money? What would you invest in if you could afford it?

What "lessons" do you feel kids today are not being taught?

Name a song or band from each music genre you like, and explain how it fits into your lifestyle.

Who is your favorite clothing designer, and what article of clothing do you love most by them?

How are rage and anger different?

If love could talk, what would it say?

How important do you think communication is in a relationship?

Do you have anything that makes you self-conscious? What are you doing to improve the way you feel about it?

Do you think the eyes are a window to a person's soul? What does eye contact mean to you?

What wastes most of your time?

Do you feel you're on the right track?

How do you keep yourself organized?

Do you still believe in anything old-fashioned? (Example: writing letters)

Describe what the term "gentleman" means to you.

Name ten things that should be peppermint flavored, but are not.

What do you think you are missing that prevents you from living life to the fullest?

How do you dress to impress?

Do you believe in soul mates? What is your definition of a soul mate?

Describe the biggest invasion of privacy you've ever experienced.

What is your favorite Olympic event? What event/sport do you think they should add that is not currently available? What event/sport should they remove?

What is the best present you've ever been given? Who gave it to you and what made it the best?

Plan your perfect birthday party.

Can beauty be found in chaos? How do you describe chaos?

Write three original fitness-related motivational quotes.

Do you have an ongoing project? What is it and how will it benefit you?

Do you often speak before you think? Has that ever hurt you?

You have to stuff a stocking for Santa. What would you put in it and why?

Do you dwell on the past, or do you move on pretty easily?

How do you cheer someone up? Describe a time when you had to do so.

Describe your perfect pizza in detail, including how it would be cooked and what toppings would be included.

Rename the following three board games to describe them better: Monopoly, Scrabble and Clue. For one game, name one additional rule you wish was in the game that isn't.

What event from your youth still teaches you lessons today? How do you apply what you learned?

Which social media app is your favorite? Why?

Is there any topic in your household or family that is off-limits, or is everything fair game?

If your mirror could speak, what would it say?

Write about something new in your life.

What are you skeptical about? Why?

Is acting a learned skill or a natural talent? Why do you feel that way?

Name something you bought on an impulse and immediately wanted to take back. If you kept it, did you regret it later?

What do you believe is your purpose in life?

What life event made you feel completely venerable?

Name three adjectives that best describe your temper. What or who was the cause of the angriest moment of your life?

Have you ever wished upon a star? What did you wish for?

What is your favorite "me" time ritual or routine?

What was your first kiss like? How old were you and who was it with?

What do you love from the 1980s decade?

What is the most beautiful part of nature to you?

If you were a witch, what would be in your cauldron?

Have you ever been the subject of a rumor? How did you handle it?

Describe ten sounds that you associate with winter.

List two things you are very passionate about. Describe your passion.

List five facts about yourself that people don't know.

Do you have any fetishes? If so, what are they?

Describe your perfect cup of coffee or tea.

What area of your life needs the most improvement, and what plans have you made to improve it?

Name something you learned from your grandparents or from someone much older than you. Did they give you advice? If so, what was it about?

What is in your medicine cabinet that you cannot live without? Why?

Do you think freedom of speech is really free?

Create five new one-word magazine titles that are not currently in use. Describe the tone of the publication and what types of articles and photos it would feature.

Have you ever lost a bet? What did you wager?

How spontaneous are you?

Write a nursery rhyme featuring an apple tree.

Name a weird mannerism you have. Do others notice it? Does it help you or bother you?

Compare yourself to a hopeless romantic.

What was your all-time brightest idea?

What is your favorite thing in your kitchen? Why?

If you were trapped in an elevator with a stranger, what would you do?

How do you think people's work ethics have changed through the years?

What do you want your legacy to be?

Name something expensive that you feel people waste money on.

Have you ever quit anything you started and later regretted it? What was it?

How has your imagination helped you?

Who is your rock? Why do you feel that way about them?

Could you ever live at the beach, or do you just feel it's a place to visit? Why?

Is there a novel you wish you had written? What do you love most about it?

How do you feel about sharks? Do you believe they are beneficial to the world?

Do you believe in fairies?

Name something you're afraid to try but really want to. What makes you afraid to try it?

Name an obligation you have, and describe how you feel about it.

You are the coach (pick any sport) and your team is losing an important game. Write a speech to motivate your team to a win.

If you looked into a crystal ball, what would you hope to see?

Name a pioneer you admire. What was their cause and why do you admire them?

What resources would you like at your fingertips?

Name something unproductive you love doing while at work.

How do you handle difficult people?

Who would you love to receive a makeover from? What would you make over? Why?

What makes you feel invincible?

Describe a perfect evening under the stars.

You have your own show in Las Vegas. Describe your act.

Have you ever been to a festival? If so, what was it like and what did you do? If not, is there one you've been wanting to attend?

How do you size up competition? Does this help you?

In what way or ways are you resilient?

Describe each day of the week as food.

Write a short book in the style of Dr. Seuss.

It's a rainy day. What would make it perfect?

Name three positives and three negatives of social media. Do you think it's a fad or the way of the future?

Do you feel that people today value marriage as much as they did 50 years ago?

Name something that gets better with age.

Would you fight for someone you love, or would you let them go?

What do you think is unpredictable? Why?

Have you ever played "Truth or Dare"? How did it turn out?

Have you ever tried anything on to see how it would fit (not clothing)?

What was the last event you attended that was worth the price of admission? What made it special?

What did you do last weekend? Did it turn out better or worse than you had planned?

If love is in the air, who do you hope catches it?

Would you trade places with one of your friends? If so, who? Why?

Who do you feel is the most influential millionaire/billionaire? Have you learned anything from them? What did you learn?

What advances in medicine have impressed you? If you had to pick a cure for one thing there is currently no cure for, what would it be?

Name something you want to buy that is vintage. Why do you want to buy it?

Come up with five catchy alternate names or phrases for "bathroom."

Create an outrageous birthday card for a friend. Describe the card's design, image and message.

What gets your creative juices flowing?

Your heart has just scheduled a meeting with you. What do you think is on your heart's agenda to discuss?

If you could call a "timeout" on something in your life, what would it be?

Have you ever experienced something that just could not be logically explained?

You're interviewing someone to be your personal assistant. What qualities and qualifications would you look for? List at least three questions you would ask them.

If you could be the leader of any country, which country would you choose? What would you change first?

Do you tend to follow the crowd or walk to the beat of your own drum?

Pick three toys from your past that are no longer sold today. Revamp them so they are relevant in today's market.

If you were to cook dinner for the President and First Lady of the United States, what would be on the menu? Where would you host the dinner and how would you set the table?

You are a children's book writer. Write the first few lines of your new book.

What is your cup of tea?

How valuable is experience?

You have to design a haunted house, and nothing is off limits to scare people. Describe the adventure in detail for your guests.

You are a guest speaker at an elementary school and you're there to address a class of first graders. What will you talk to them about?

Name something you feel is dangerous that others may not. Why?

If you could ask Abraham Lincoln one question, what would it be?

You have been given a million dollars to donate to charity. Where would your donation go and why?

If you had the power to make something illegal that is currently legal, what would it be? Why?

Create and design a new board game. What is the name and how do you play it?

Create a fun and adventurous "flash mob" experience. Describe the place, scene, music and scenario.

You are opening a traveling circus. Describe your featured acts and their talents.

Do you believe wisdom comes with age, experience or both? Elaborate.

Close your eyes right now. What was the first thing to pop into your mind?

If you could take any celebrity to lunch, who would it be? What would you ask them and what would you hope to learn from them?

Write ten new sayings for Confucius that he has not yet said.

Name a fashion or trend that is currently out of style that you wish would make a comeback.

Write a limerick about a vampire.

Name something that feels right every time you do it.

Write a new slogan or jingle for your favorite candy or snack.

Finish this sentence: "This was not supposed to happen..."

If you had to model something, name what you'd be good at modeling and explain why.

Name something you know will change your life but can't bring yourself to do.

If you could be a fly on the wall anywhere, whose wall (or what wall) would you choose, and why?

You have a chance to mentor a troubled teen. What do you talk about that will make an impact in their life?

Write a journal entry from the Statue of Liberty, dated today.

What is your before-bedtime routine?

If you fell down a rabbit hole, what do you think you'd find?

In what way are you a trendsetter in your social circle?

How do you feel about superstitions? Do you have any?

What do you think a turtle would be like without its shell?

Describe science in three sentences.

If you had a theme song that played every time you entered a room, what would it be? Who would sing it?

How do you "think outside the box"?

What is the funniest prank you have ever played on someone? If you haven't, then design a prank that would make you laugh non-stop.

Have you ever considered giving something up? What is it and why?

Do you always have to have the last word? Why?

How do you feel about public speaking? What would be your topic of choice?

How often do you daydream? What do you daydream about most?

What makes you nervous? How do you calm yourself down?

What has been your greatest self-discovery?

Write a new chapter in your life right now.

How many social media accounts do you have? Do they help you or distract you?

What is your kryptonite and why does it have power over you?

You are taking a lazy drive down scenic back roads. Describe your perfect car for the ride, and name the top five songs you would cruise to.

Have you ever negotiated something successfully? What was it?

What three professions do you hold in high regard? Why?

In what way are you fragile?

Have you ever loaned someone money that didn't pay you back? What did you do, and how did you leave the issue?

Name an emotion you wish you could no longer feel. Why?

Name and describe five silly things you do.

Describe a really bad experience with a place or business, after which you decided to never go back.

What makes you feel like a kid again?

Do you have an alter ego? What is that personality like?

Have you ever been accused of something you didn't do? How did it turn out?

Would you ever sign a prenuptial agreement? Would it upset you?

If you had an extra room in your house, what would you use it for?

What makes you feel empty?

Do you think *feng shui* is beneficial?

How do you read between the lines?

Describe your perfect picnic. What's in your picnic basket?

What was the last thing you were enthusiastic about?

Write a different version of the fairy tale "Hansel and Gretel."

What do you do for an adrenaline rush?

Where is the most exciting place you've ever made out with someone?

What would your friends say is your best quality?

Do you prefer the new e-books or printed hardback or paperback books? Why? What are the benefits of each?

Name something you could not be objective about.

What makes a lady/woman classy?

Have you ever competed in anything (team sports, spelling bee, etc.)? What did you learn from it? Did you like it?

You're a used car salesman. What is your best sales pitch?

You have a job interview, and the only requirement is to buy a gift for your future employer whom you've never met. You cannot spend more than twenty dollars, and it must be gender neutral. What do you buy or make?

Do you think energy drinks work? Have you ever taken one, and did it help you?

If you could create a charity, what would it be called, what would be the cause, and what celebrity would be your spokesperson?

Have you ever been envious of someone? Why?

In your opinion, what makes the "heart of a champion"?

Which actor/actress has the most soothing voice for narrative purposes?

Are you dependable? Describe a time you really came through for someone.

Plan an elaborate and wild wedding proposal for your best guy friend that is so over the top, the bride won't say no.

Create a riddle involving a mouse, a wheel and a rose.

What is your favorite thing to do in a park? How often do you go?

What day of the week do you most look forward to? Why?

It's open mic night at your local comedy club. Your friends have just dared you to take the stage. Write your opening line and three original jokes.

Have you ever fainted or come close to fainting? What made that occur?

Who do you trust most in this world? Why?

Write a comparison of the last two books you read.

Have you ever lost control of a situation? How did it happen?

What was the worst insult you've ever been given? How did you handle it?

Create an original ghost story to tell to a group of boy scouts sitting around a campfire.

Name five things you learned this year. Were they beneficial?

If you could sit down with any outlaw or criminal (past or present), who would it be? Why? What would you ask them?

You're barefoot in the sand on a beach, and the waves run over your toes. Describe what you are feeling.

Has William Shakespeare influenced your life in any way? If not, how do you feel about his work and its impact today?

Describe a home remedy that has been passed down in your family. What was it used to treat or cure? Does it work?

Do you meditate or believe in meditation? If you do, does it help you?

Do you believe in multitasking or in focusing on one thing at a time? How does this help you or hurt you?

What is the biggest argument you've ever had? Who was it with?

Describe a great "comeback story" you've heard in the media that made you really root for that person. Have you ever made a great comeback?

Describe a missed opportunity from your past and how it affected you. How do you think it would have changed the course of your life if you hadn't missed it?

Describe something that is forever.

Have you ever burned a bridge you wished you could rebuild?

Have you ever had a moral victory? Describe it.

Are you a morning person or a night owl? What makes you flourish in that hour?

Describe someone you know who is self-made.

Have you ever made anything by hand? What was it?

Do you believe happiness is a choice?

Do you currently volunteer? If so, what do you do? Is it rewarding? If you don't volunteer, would you? Where would your time be best put to use?

Come up with a more exciting way to say "I love you."

How do you learn?

Create and describe a memorable moment you can plan for someone special in your life.

You're ten years old and opening a lemonade stand. Describe what it looks like and what you would say to potential customers to get a sale.

What recreational class would you love to try (pottery, knitting, cooking, etc.)? Why do you want to try it?

Name a major international city that you would never live in. Why not?

Create your perfect stir-fry dish. Why did you choose those ingredients?

Do you think there is a secret to success? How would you describe success?

Name something you would never compromise on. Why?

Name a thing or an event from your childhood that scared you. Does it still scare you today?

Name three things that make your day perfect.

Give five reasons why you would make a great lawyer.

In what ways are you above average?

Have you ever had to face your fears? What did you do?

If you could boldly go where no man has gone, where would you go?

Describe the way the rain smells to you.

Name a super power you'd love to have. Would you use it for good, or for personal gain?

What do you need a dozen of right now?

Does creating a "pros and cons" list help you?

What celebrity or public figure rubs you the wrong way? Why?

Create five new endings for this phrase: "Mirror, mirror on the..."

You're a squirrel and you've just fallen out of a tree onto a trampoline. Write what is going through your mind and be colorful.

Are you moody? Describe all your moods.

Which fairy tale do you most relate to?

What is something recurring on your "to do" list. Why are you putting it off?

Name five things that are better creamy.

Elaborate on the phrase "cold as ice."

How would you engage a hostile audience?

Has a close friend ever betrayed you? How? Have you forgiven them? Are you still friends?

Do you think family values still exist? Do you have any?

Describe the perfect ending to a stressful day.

Do you prefer online shopping or in-store shopping? Why?

What is one thing you will never share? Why?

Do you have a secret hiding place? What do you hide there?

What's the nicest restaurant you've ever been to? Where was it? What did you order?

Have you ever been asked to play Cupid (matchmaker), or have you ever asked anyone to play that role for you? How did the experience turn out?

Create a new nemesis for Batman. What is the character's name? What is their feud about? Describe a short scenario, comic book style.

What movie (past or present) do you wish you could have starred in? Is there any other cast member you would change and would the ending be the same?

Do you listen when people give you advice? Do you give advice?

Do you or anyone you know have a disability? Has it strengthened you/them in any way?

Name something you've tried and failed at. Are you still trying? What is your latest approach to gain success?

What brings out your softer side?

Do you consider yourself to be a genius on any subject or topic? If not, name a subject you wish you were a genius in.

Name five foods that are better spicy. Why?

What does the term "power of persuasion" mean to you? Have you used it?

Has your pride ever gotten in the way or caused you to lose something important?

Have you ever collected anything (stamps, rocks, etc.)? Why did you start it and what made you collect that particular item?

Do you do anything to combat pollution? If you were in a position of power to reduce pollution, where would you start?

What do you think when you hear the word "Monday"? Why?

List your top ten reasons for reinventing yourself.

Name three things you absolutely hate doing. What would make you enjoy them more?

When you think of California, what comes to mind?

What do you crave? How often do you crave it?

What part of your daily routine do you most wish you could skip?

Do you care what people think about you? How do others' opinions affect you?

Explain Google in five sentences or less.

Have you ever been fired or fired someone? How did you feel? What did you do?

What is something you consider unforgivable? Or can you forgive any offense?

Do you believe in luck? Do you have a "lucky charm"?

Have you ever fallen in a public place? What did you do right after you fell?

Have you ever made a bad first impression? Who was it with? Do you still talk with that person?

Have you ever carved a pumpkin? What did you design? Describe the experience.

If Charlie Chaplin could speak, what would he say?

Describe a former boss you have had, or your current boss. Did you learn anything from them? What type of management style did they have?

Name your favorite childhood cartoon. Do you have any special memories associated with it? What did you love most about it?

Are you a cat person? A dog person? An animal person in general? Do you believe pets add joy to their owners' lives?

Do you believe in ghosts? Have you ever been or lived somewhere you thought was haunted?

Have you ever paid it forward? Do you think that is important?

How do you feel about texting, rather than calling, a person?

What is more romantic to you: moonlight or sunset? Why?

Have you ever refused to help someone when they needed it? Why?

List several things you like about the sun.

Name a popular product with a major design flaw. How would you correct or improve this item?

What profession do you feel is too greedy, and why?

Name a daily source of inspiration. What about it inspires you?

Define what bravery means to you. Who do you know that is brave, and why?

Name a video game (past or present) that best describes your life.

Do you criticize people too much or not enough?

How does your intuition serve you? Do you put merit on "gut feelings"?

What story or tale from your childhood brings you comfort?

What are your thoughts on the zombie craze? Is it hurting society, or is it all in good fun?

How do you handle bad influences in your life?

What does the term "walk the line" mean to you?

Do you work well under pressure?

Create three new ways to say "green thumb."

What animal pattern for clothing exudes the most confidence? Why?

What do you think the phrase "rose-colored glasses" means?

Do you believe you can teach an old dog new tricks? What would be your approach?

What is the best lie you have ever told? Why did you tell it? Did the person ever find out?

Plan out a scavenger hunt for three couples getting married. Include all the details from start to finish. What treasure will be waiting for the winners?

Name someone you owe an apology, and explain what the apology is for.

Are celebrities today hurting or inspiring our youth?

Do you have a secret crush on someone? Why is it still a secret?

Name the funniest or most creative costume you have ever seen or worn.

Have you ever wanted to set a world record or break one? What was it? Describe your plan of attack for doing so.

Is there a question you still have no answer to?

Describe your brainstorm sessions.

Describe ways you've had to adapt to or overcome something.

What's the most versatile thing in your life?

Have you ever fell into a "stereotype"? How did you feel?

Have you ever tried a product and instantly fell in love with it? What was it, and why did you love it so much?

What would you do if you were invisible for a day?

What if "life" gave you a pop quiz? In what area or subject would you get a failing grade?

Do you panic easily? What is the one thing that can quickly work you into a panic?

Have you ever given yourself an attitude adjustment? Explain.

What instrument would you love to learn how to play?

Have you ever spoiled yourself? What did you do, and was it a special occasion?

What is missing from today's public school systems?

Are you afraid of the dark? What do you love or hate about it?

What is your definition of discipline? In what area of your life do you exercise the most discipline?

How would you explain the saying "dog-eat-dog world" to a child?

You have to give each room in your house or apartment a name. What are the names of each room, and how did you come up with those names?

Do you believe there is a Bigfoot-type creature out there? How do you feel about it?

Have you ever settled for something?

Pick a famous warrior from history that you would be honored to fight alongside. What do you like most about them?

Give five alternate, original endings to this famous phrase: "Frankly my dear..."

How do you feel about chocolate? What is your favorite way to eat it?

Have you ever had a hidden agenda? Why was it hidden?

Describe your perfect road trip.

You're a diamond in the rough. What made you rough and what sharpens your edges?

Name the animal that you most identify with, and explain why. Is it spiritual, or the animal's personality traits? What draws you to this creature?

Write a journal entry from a scarecrow on the night of a full moon.

If you could be serenaded with a private concert for one, who would the singer be? Describe the scene and what you'd like to have happen.

Describe what your imaginary friend would look like. What would their personality be like?

Has persistence ever paid off for you? Describe the situation.

Why do you think taxis are yellow? If you could choose a new color, what would it be?

Give creative answers to life's greatest questions.

Write a short rap song about yourself. Make sure it rhymes.

Have you ever experienced the phrase, "When it rains, it pours"?

Describe your perfect staycation. Would you want to spend it alone or with someone?

If you could pick any generation to grow up in, which one would you choose? Why?

What types of sounds would you love a clock to make?

What is something that fascinates you, and why?

You're a moth; what is your flame? What draws you to it?

Describe your perfect "room with a view."

Name a category or criteria all major beauty pageants should have, but don't.

You are designing a patchwork quilt of your life. Each square represents something significant or special. Describe it below.

In your opinion, what is a gift that keeps on giving?

Do you enjoy the simple or the finer things in life? Give an example.

Name something very popular that you feel is totally overrated.

If your life was going to be a major motion picture, what actor/actress would you want to play you? What characteristic(s) do you think you would have in common with them?

If you were given a farm, what would you grow? What animals would be on your farm?

What rejuvenates you the most whenever you feel burnt out?

Create your own flavor of potato chips to be sold in stores. Describe your new creation in detail, and design a marketing slogan for your commercial.

What would you love to wake up to every morning? Explain why. (Examples: bacon frying, ocean waves, a person, etc.)

Name a product currently on the market that you feel needs improvement. Why?

Have you ever had a "fork in the road" moment? What did you do?

Create a robot to fit your lifestyle and name it. What would it do and how would it help you? Would you trust it?

If your family had a mascot, what would it be and why?

You must pack a time capsule to be opened 100 years from today. What would be in it? Also, leave a note to the recipient telling them something they wouldn't already know.